D1725245

KALLE PIEPER

SANGO

JANSSEN

© JANSSEN PUBLISHERS CC
 P.O.Box 404, Simon's Town, 7995, South Africa

© Photographs by Kalle Pieper

Production/Herstellung: Druck- und Verlagshaus Erfurt GmbH

Scans/Repro: UNIFOTO, Cape Town, South Africa

Distribution/Vertrieb:
LKG - Verlagsauslieferung, Pötzschauer Weg, D - 04579 Espenhain, Germany
Janssen Verlag & Versand, Postfach 150 701, D - 10669 Berlin/Germany
Bookazine Co. Inc., 75, Hook Rd., Bayonne N.J. 07002, USA

ISBN 3 - 925 443 - 83 - 5

Printed in Germany 1998

For catalogue and mail order information please write to:
JANSSEN VERLAG & VERSAND, P.O.Box 150 701, D - 10669 Berlin/Germany
Phone: (+49) 30 - 881 74 69 Fax: (+49) 30 - 885 43 44
E-Mail Berlin: fvjanssen@aol.com E-Mail Publisher's Office: janssenp@iafrica.com

ACKNOWLEDGMENT

I LIKE TO SAY THANK YOU TO ALL MY MODELS IN THIS BOOK:

RAY
GABRIEL
JOHN D.W.
JEFFREY
BERNARD
GUY
CARL
LEE
JOSEPH
JOHN F.
VICTOR
DWAINE

WITHOUT YOUR TIME AND CONFIDENCE THIS BOOK COULD NOT HAVE BEEN CREATED.

I WOULD ALSO LIKE TO THANK ALL MY TEACHERS AT THE SAN FRANCISCO
PHOTOGRAPHY CENTER AND JIM JAMES.

MY FIRST BOOK OF PHOTOGRAPHY WAS MADE UNDER THE INFLUENCE AND SPIRIT OF
SANGO. SANGO IS THE DEITY OF THUNDER AND LIGHTNING, AND MALE FERTILITY.
I DEDICATE THIS BOOK TO MY GUARDIAN ORISHA SANGO KABO SILE.

SANGO
IS DONAR, THOR, SANTA BARBARA (IN EUROPE), OSIRIS (IN EGYPT), INDRA (IN INDIA), SAN
KAN FONG (IN CHINA), AND BARAKIEL (IN THE KABALA).

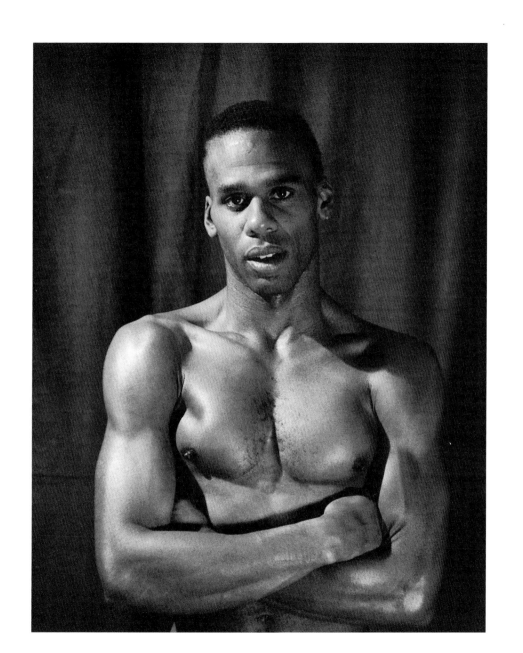

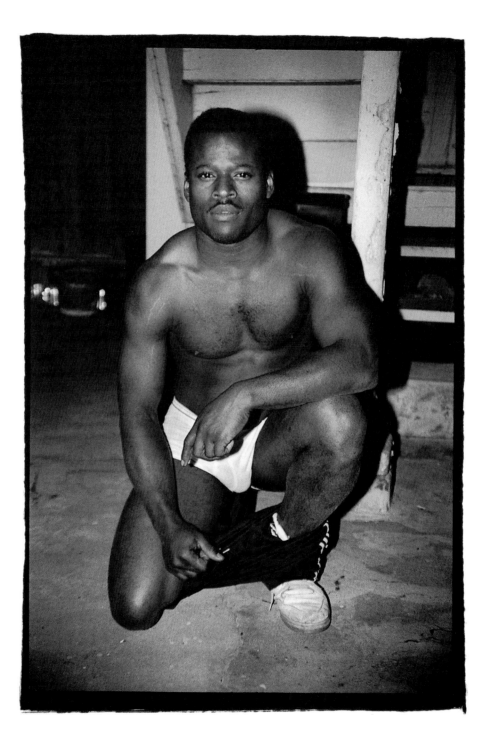

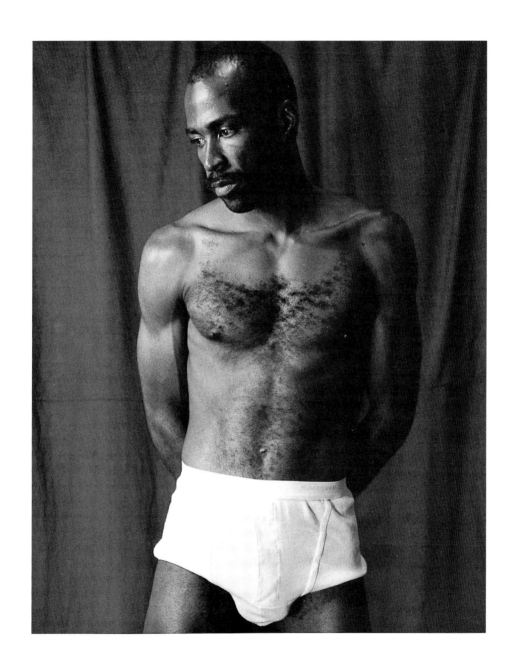

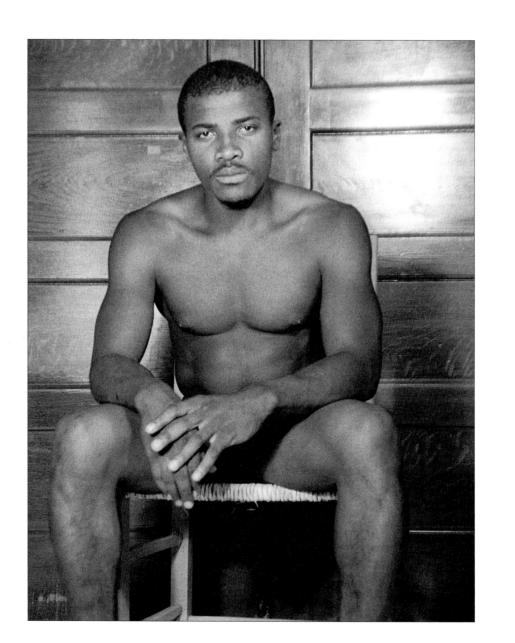

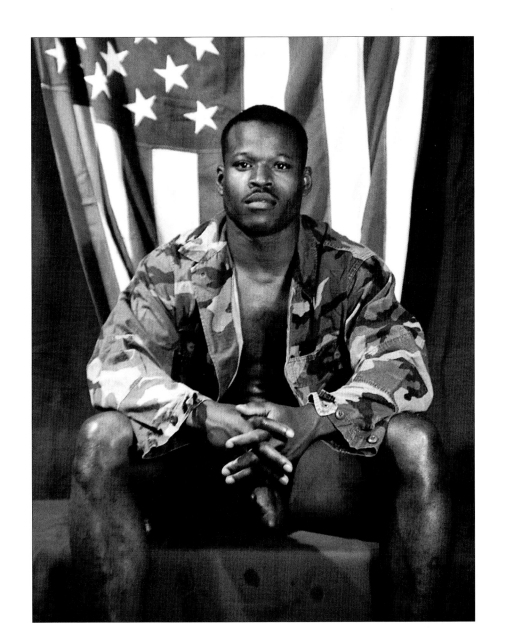

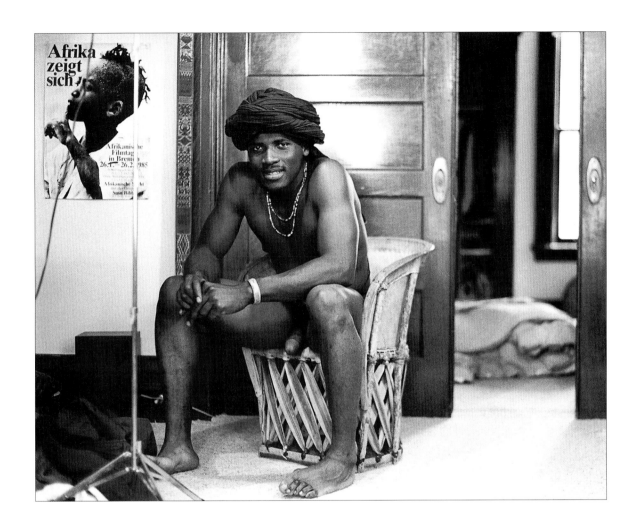

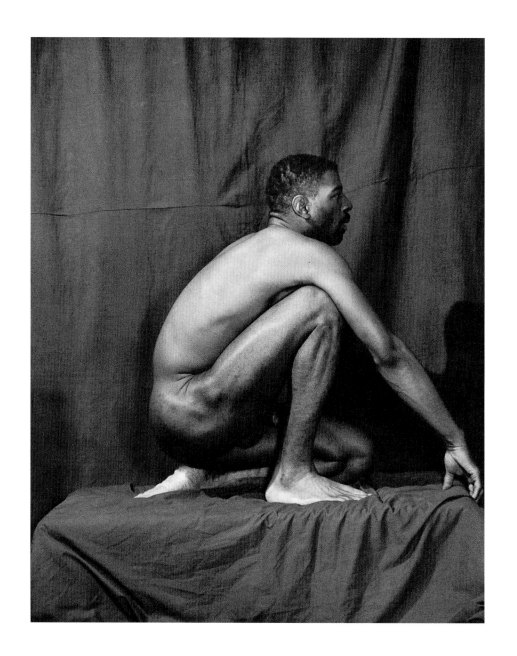

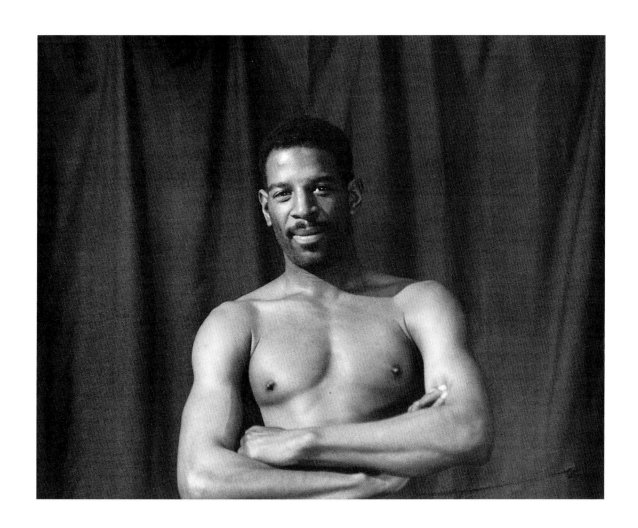

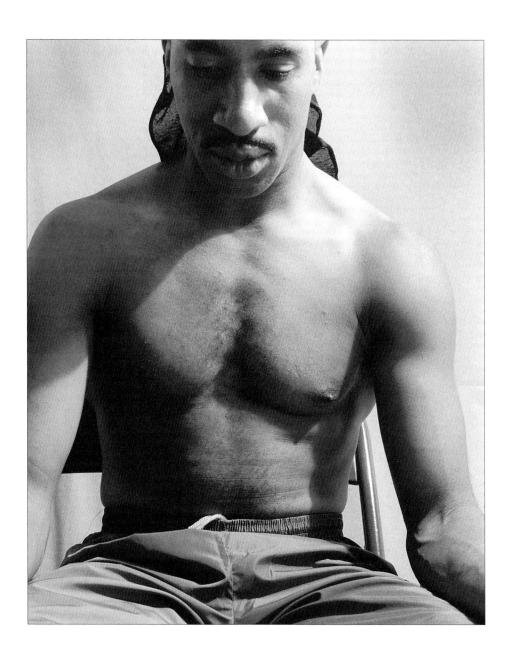

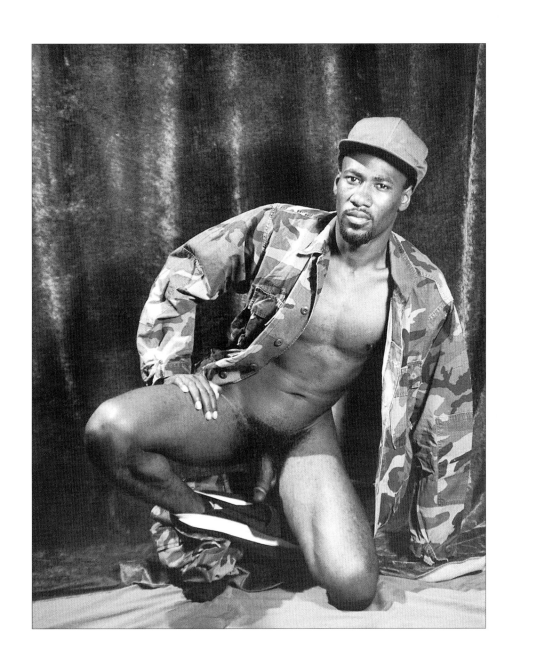

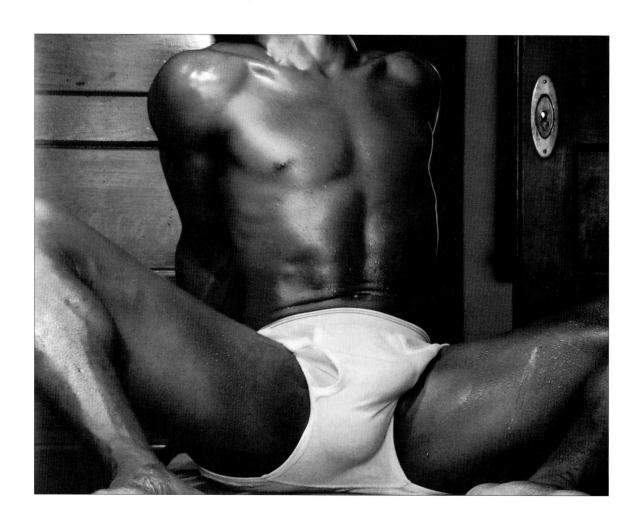

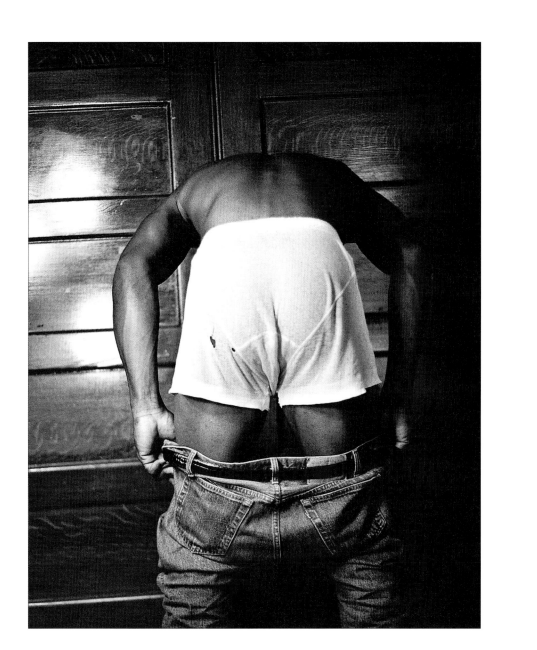

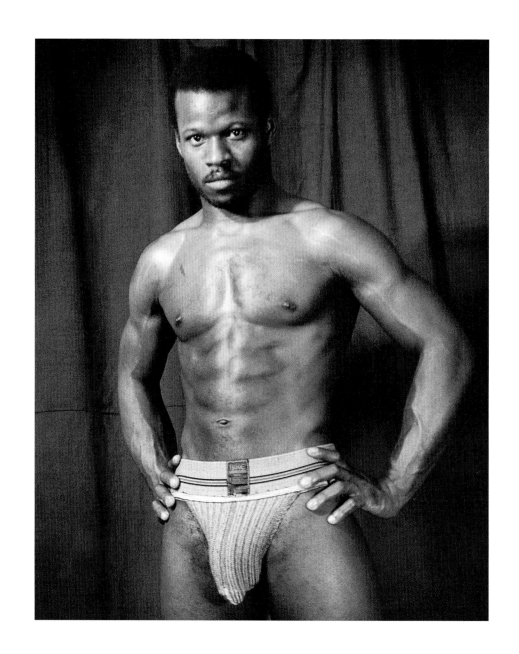

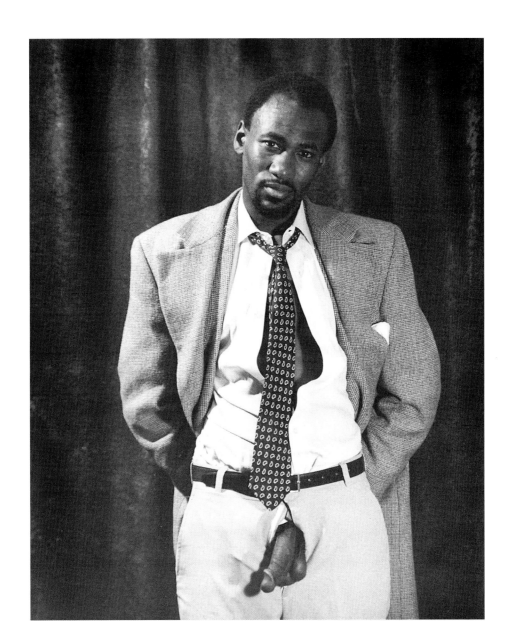

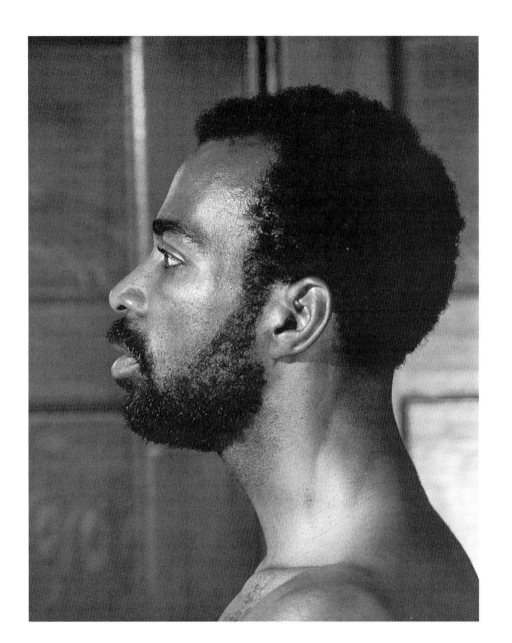

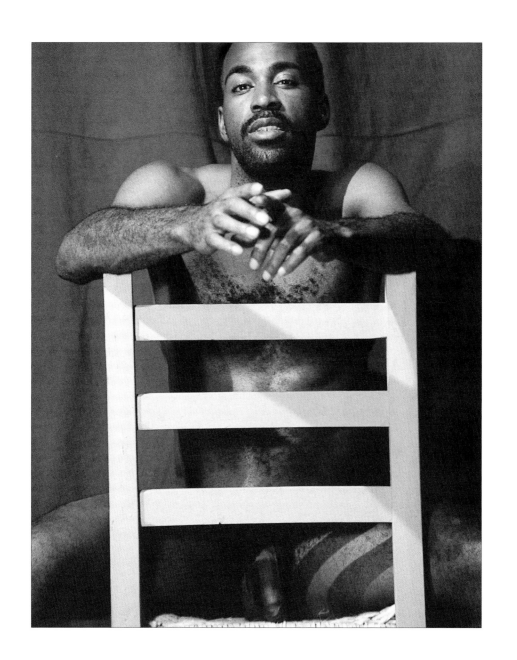

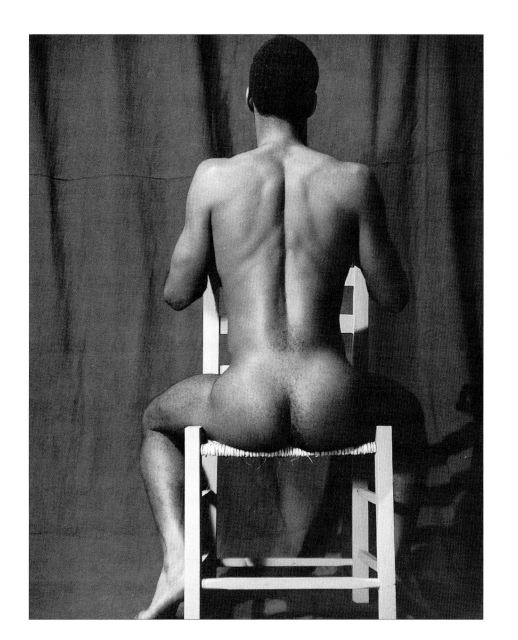

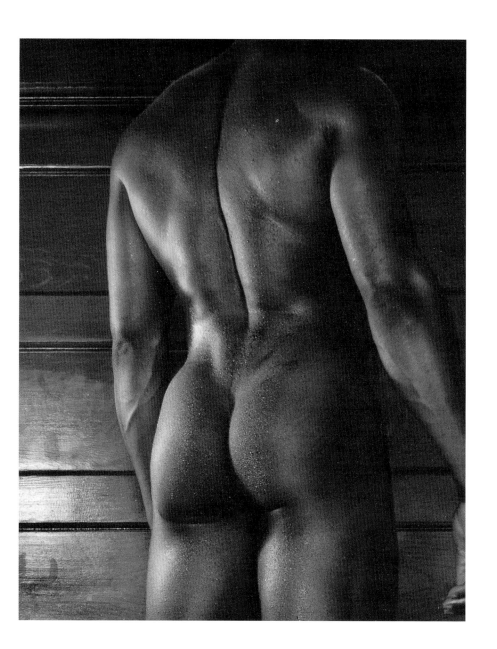

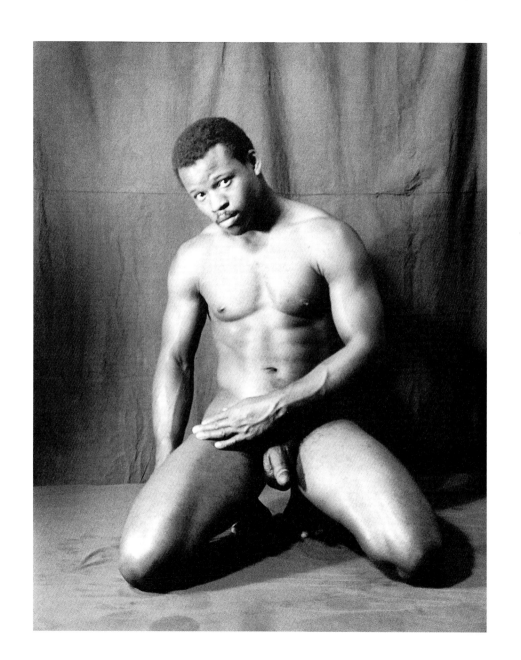

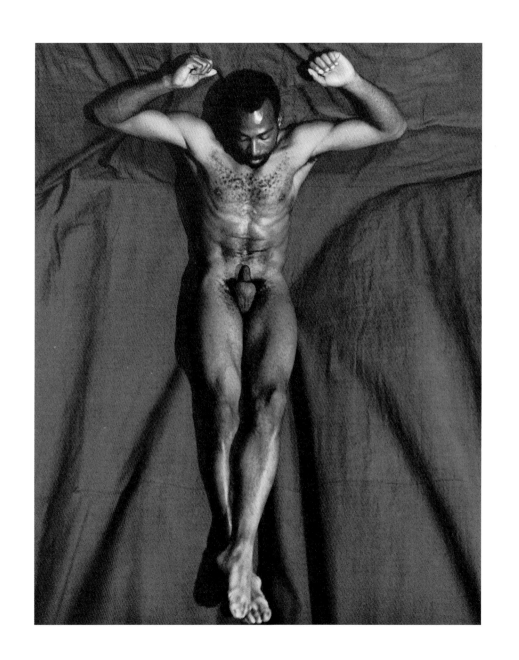

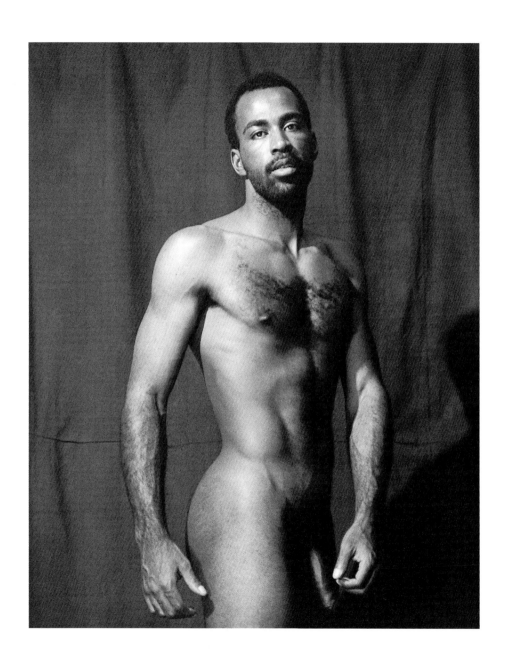

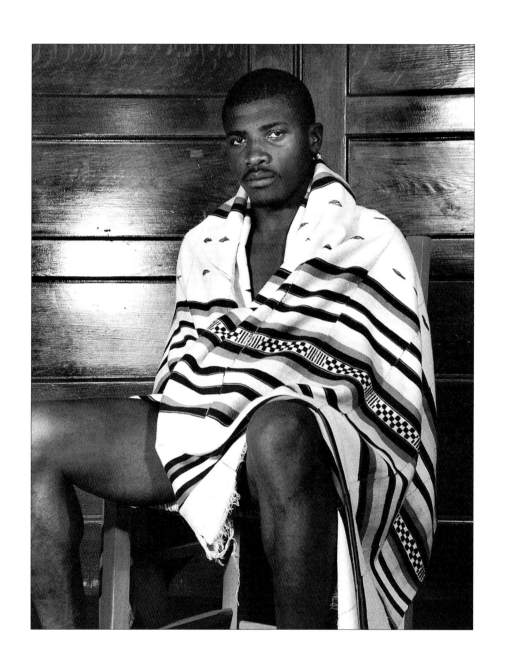

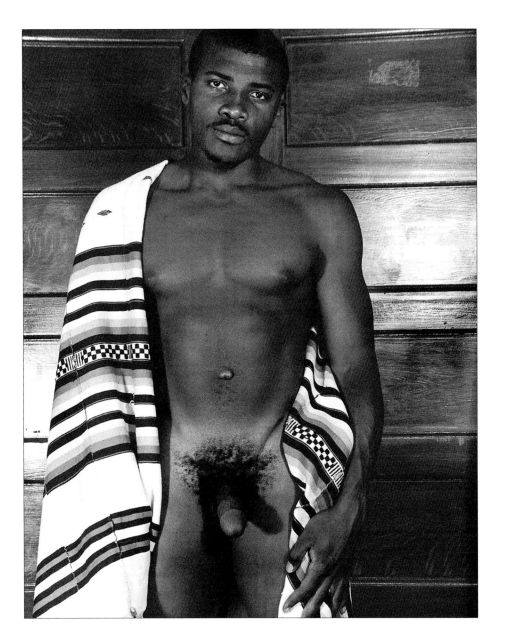

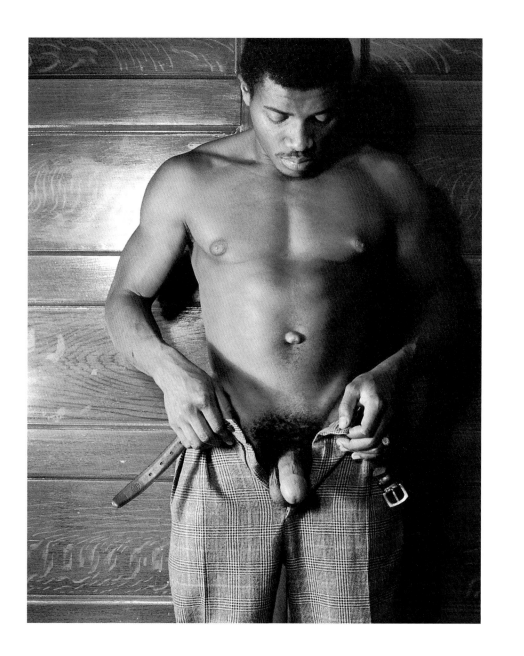

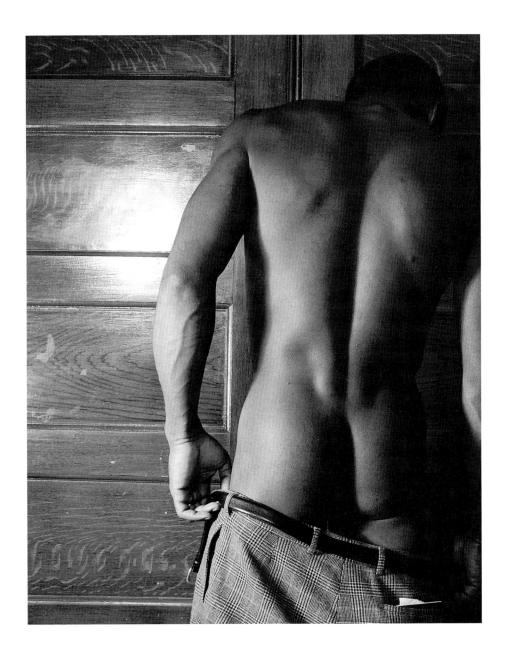

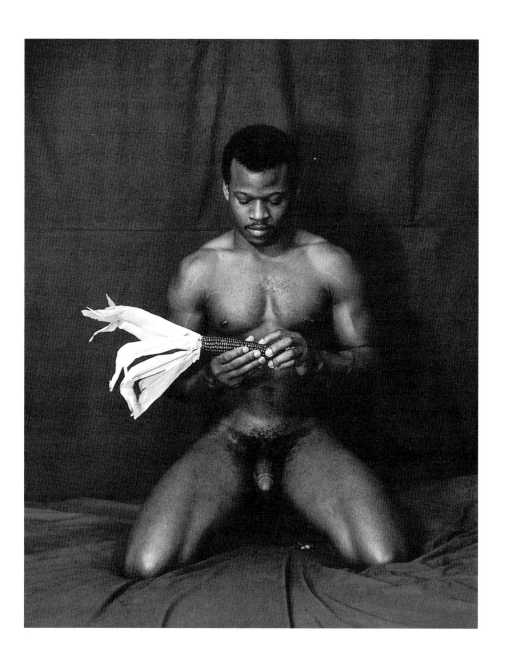

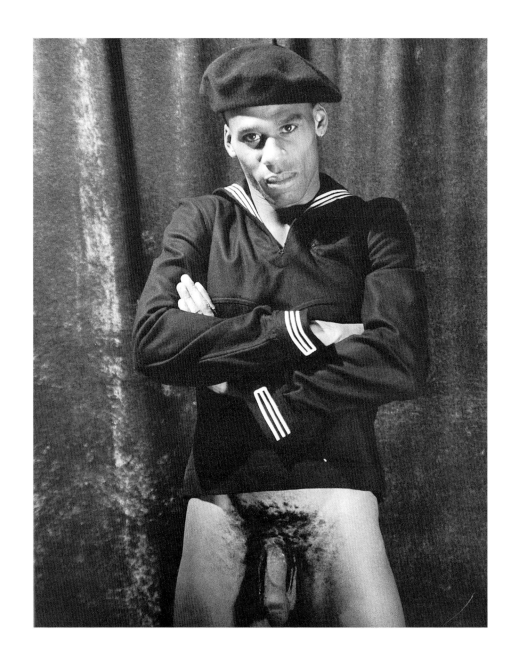

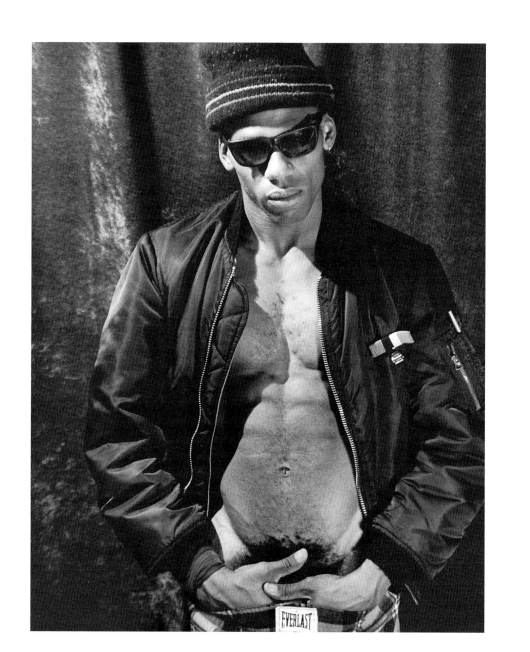

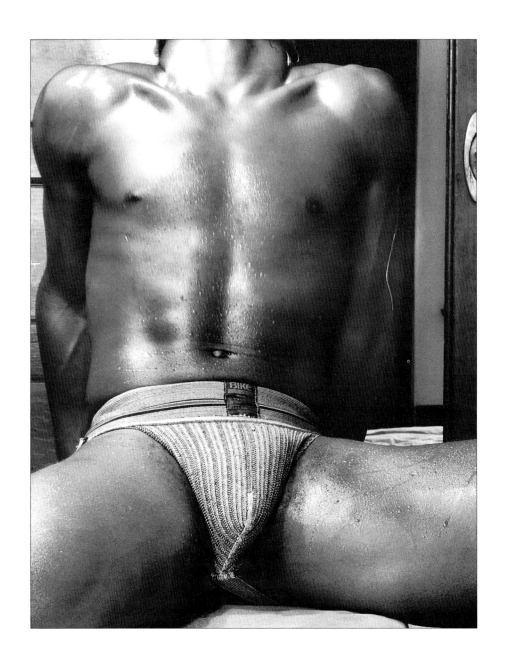

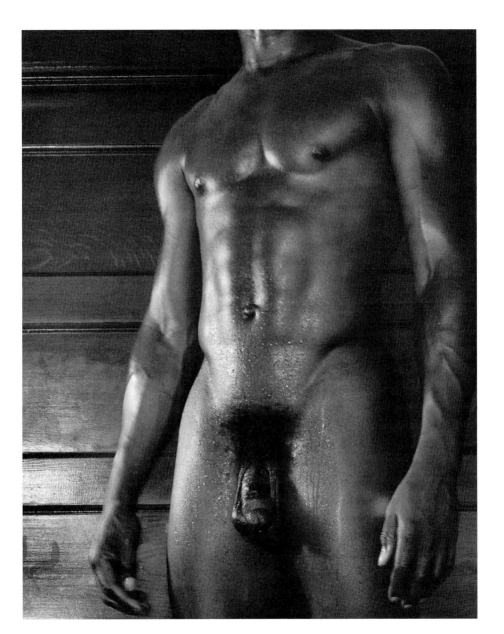

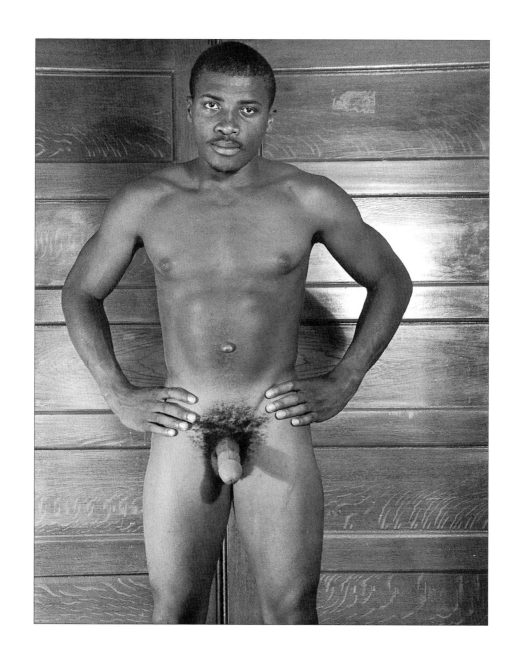

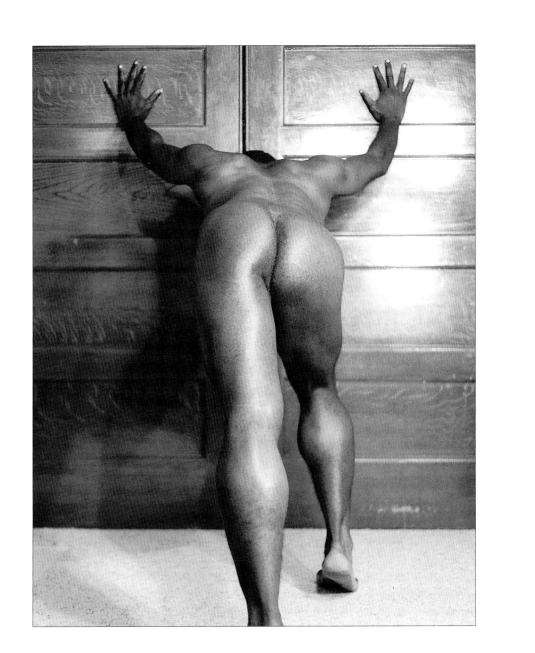

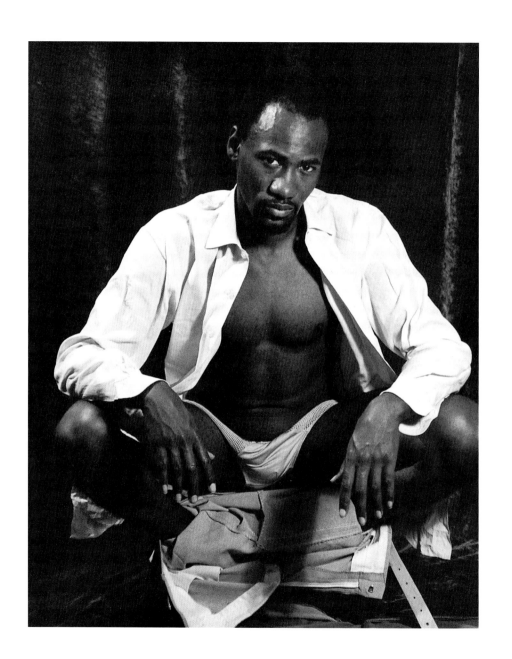

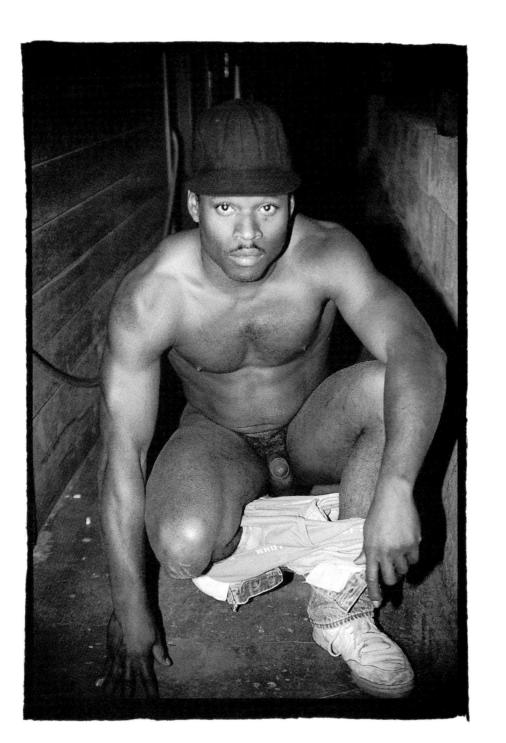

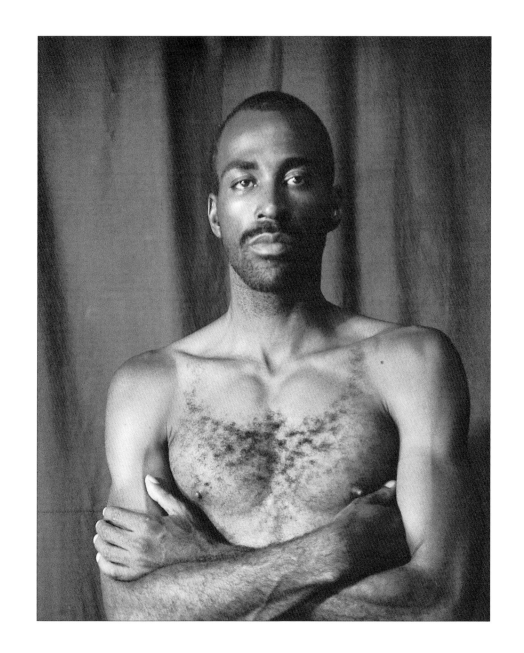

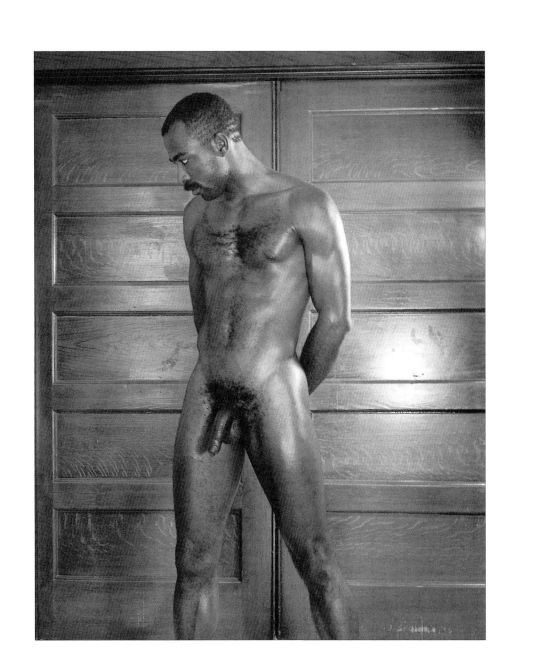

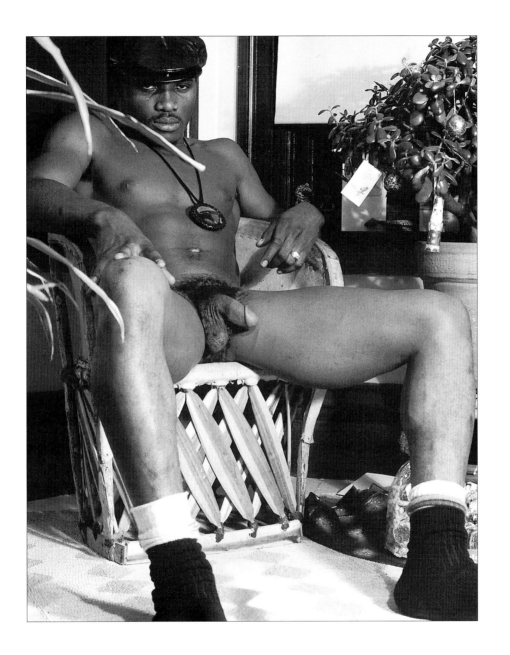

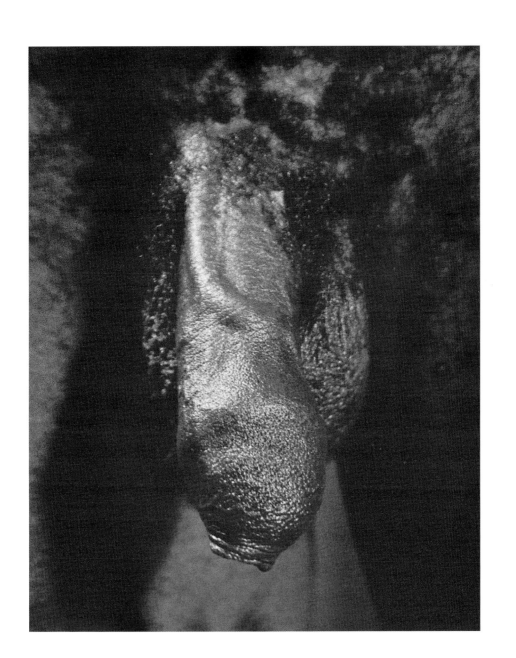

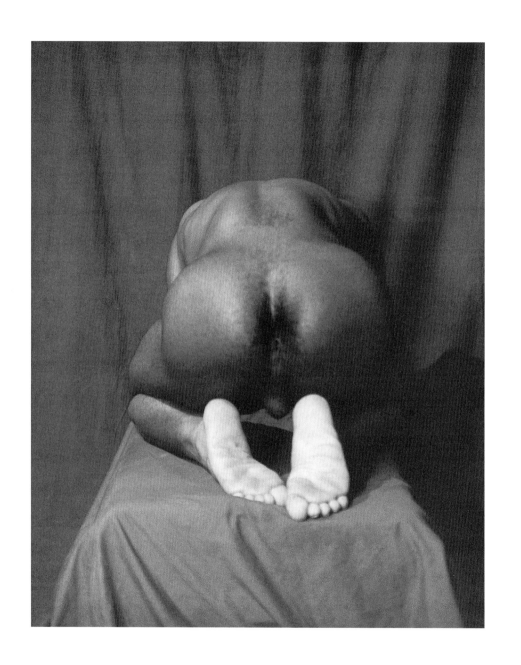

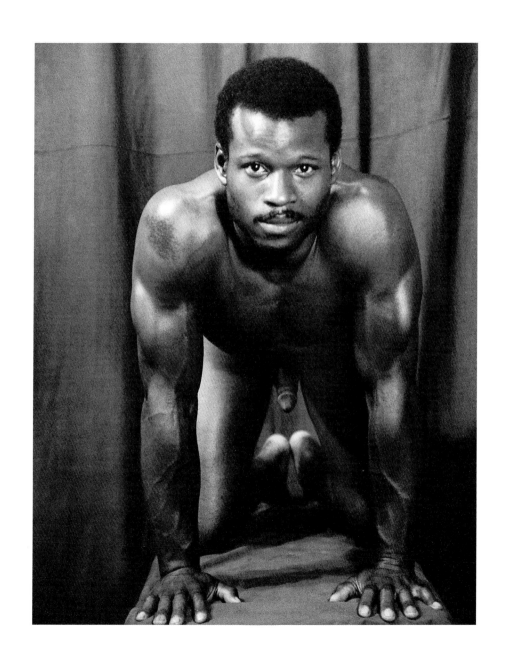

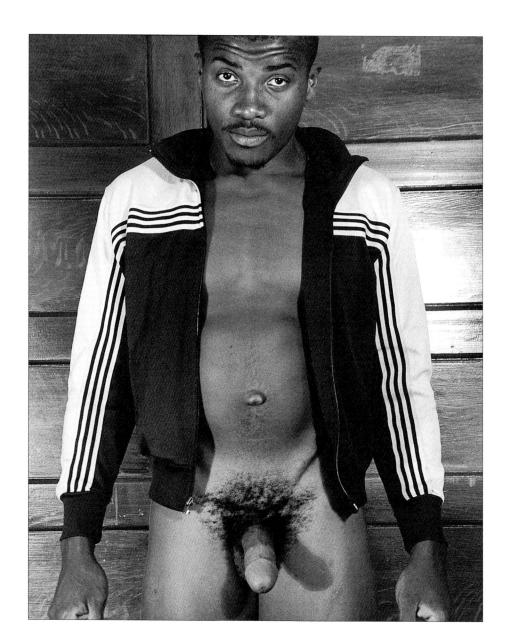

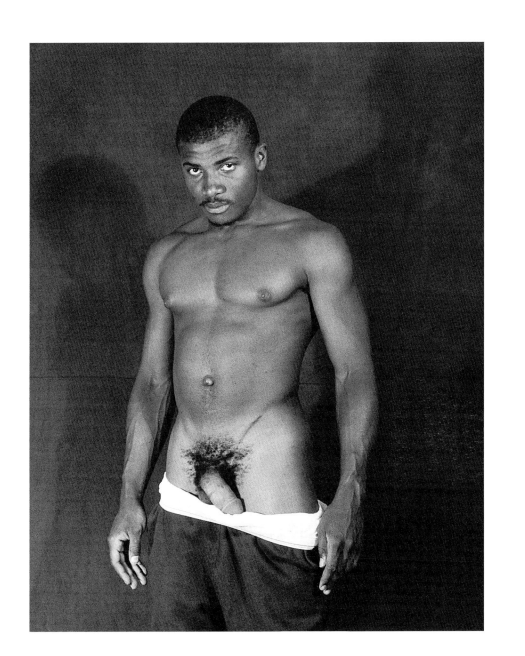

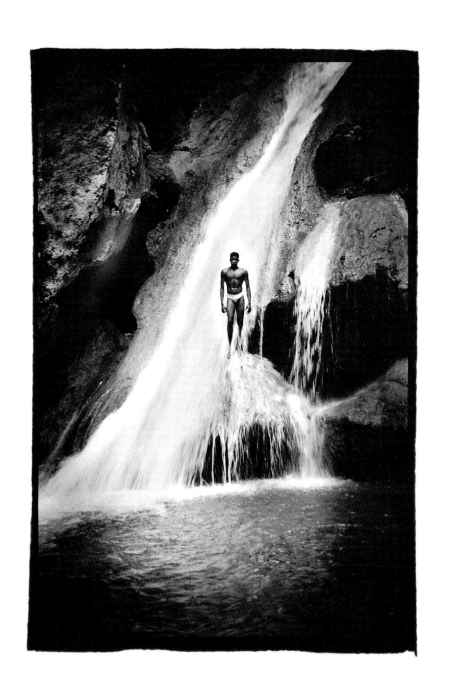

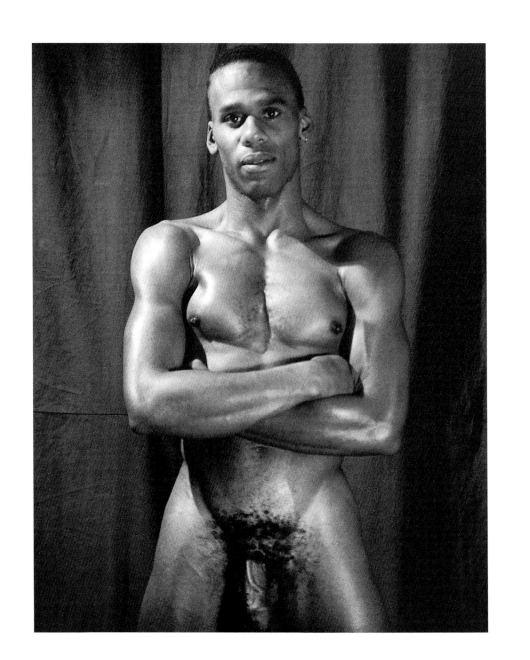

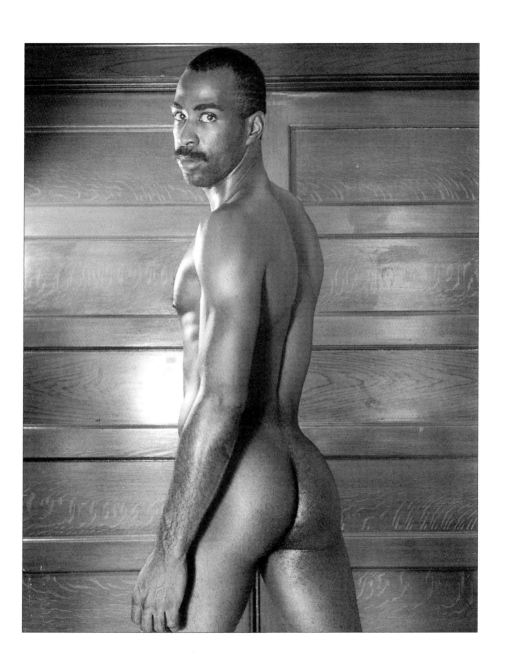

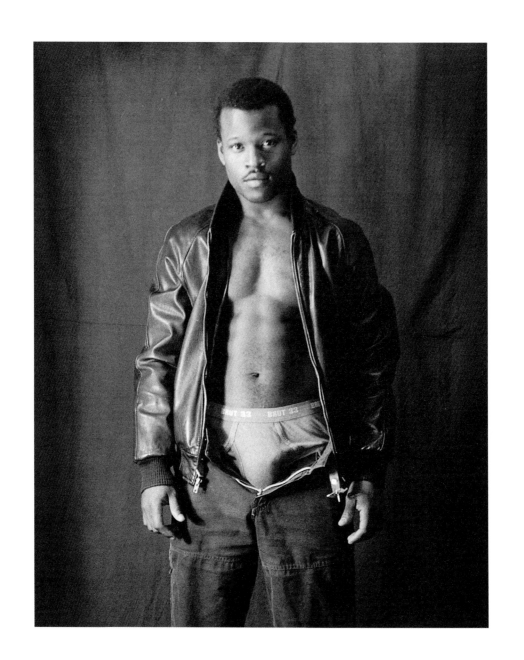

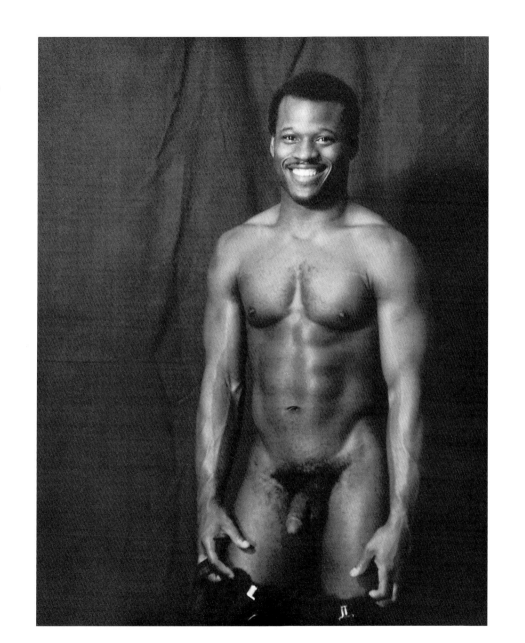

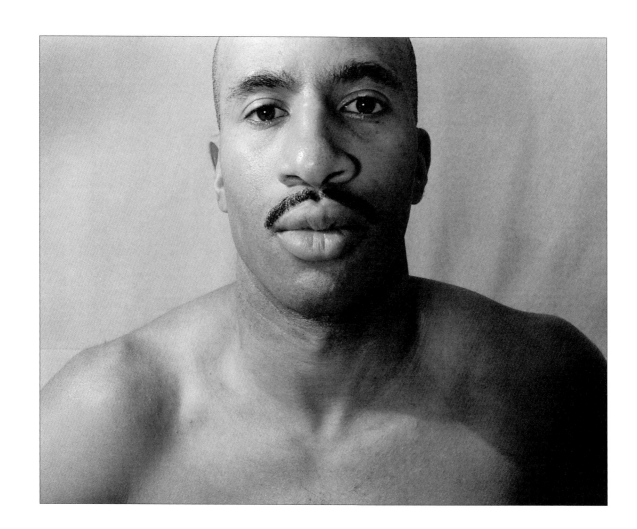

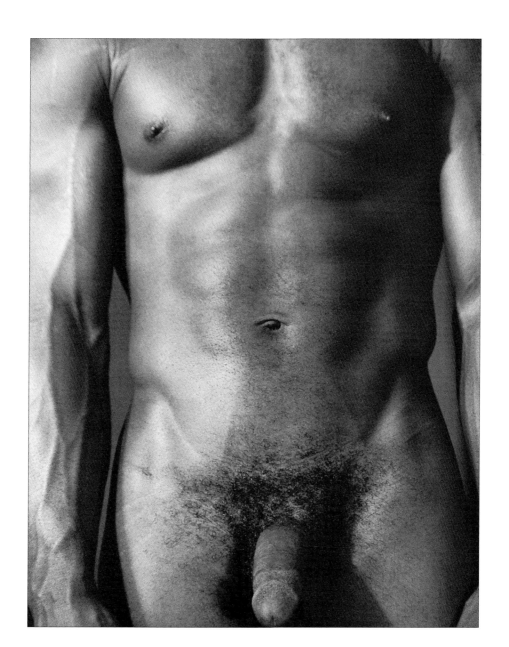

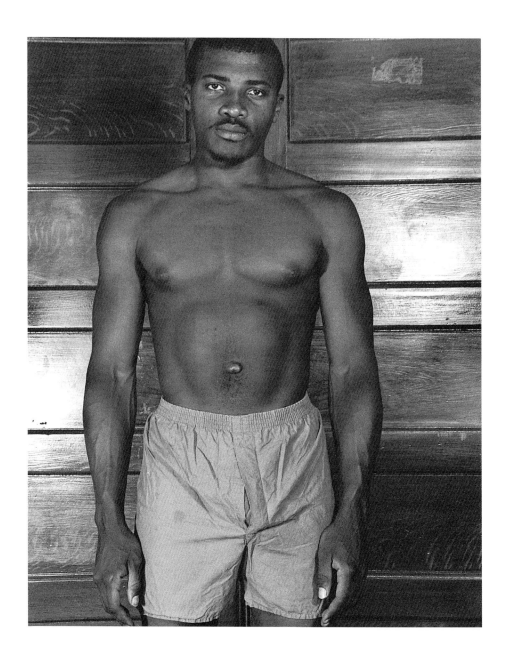

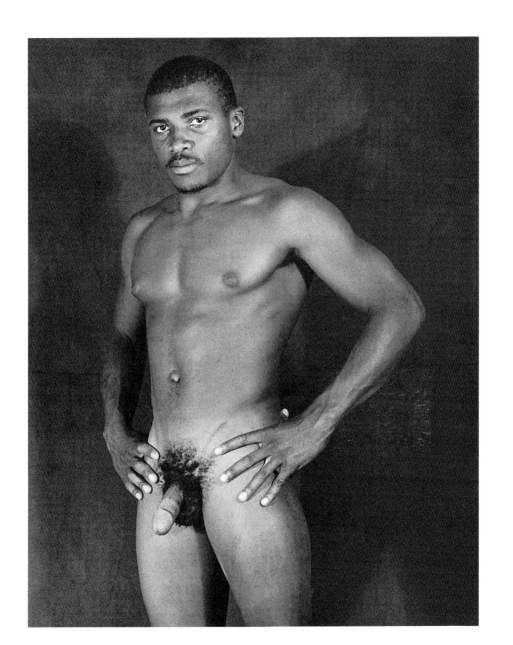

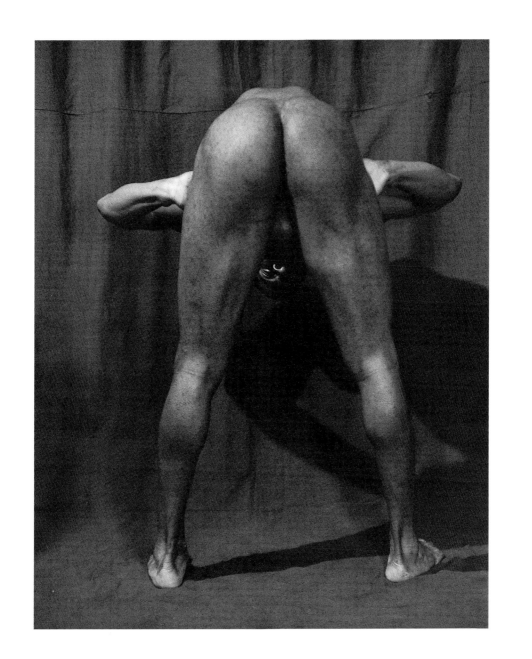

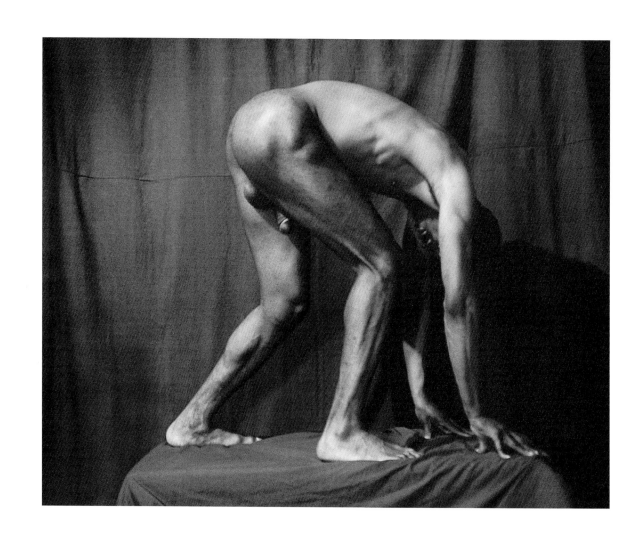

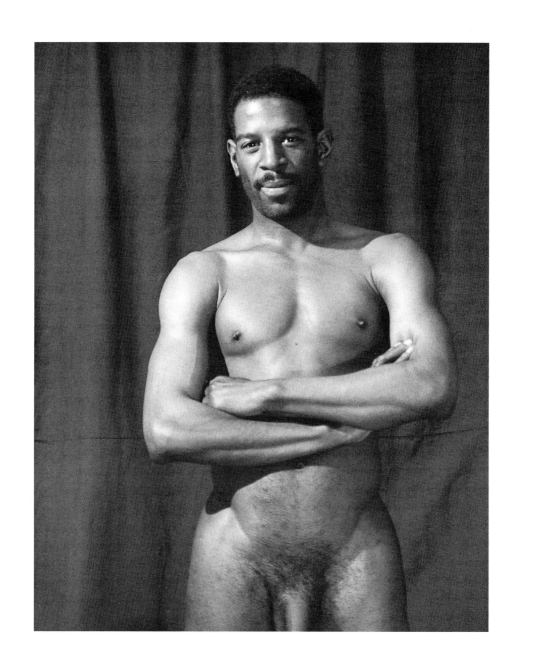

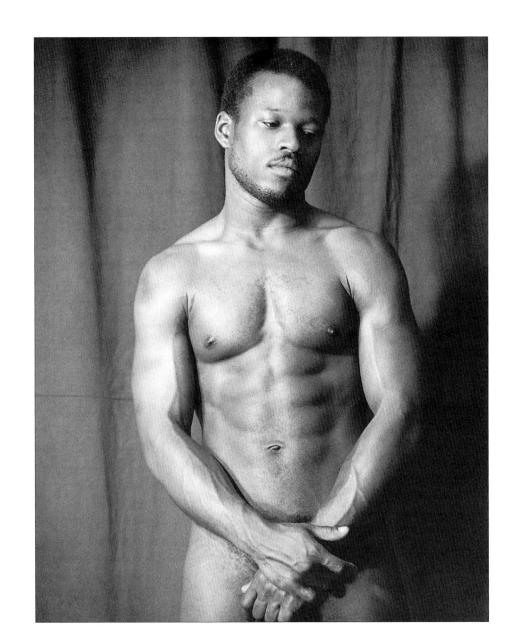

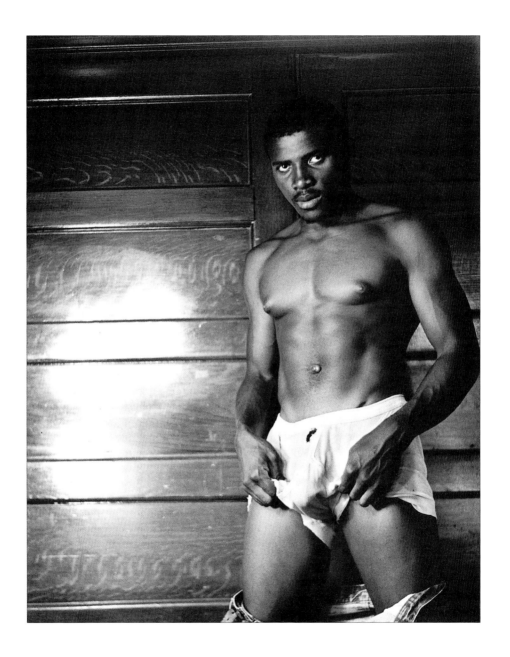

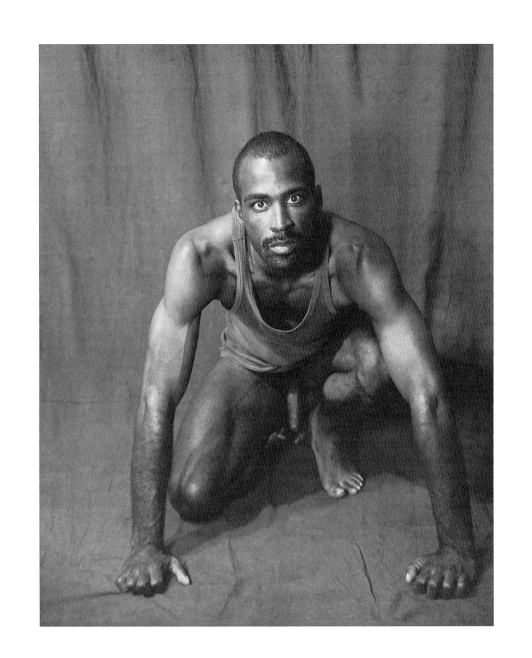

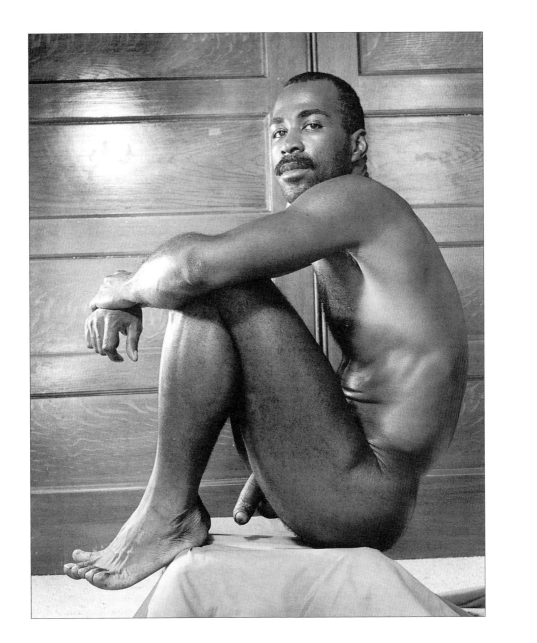

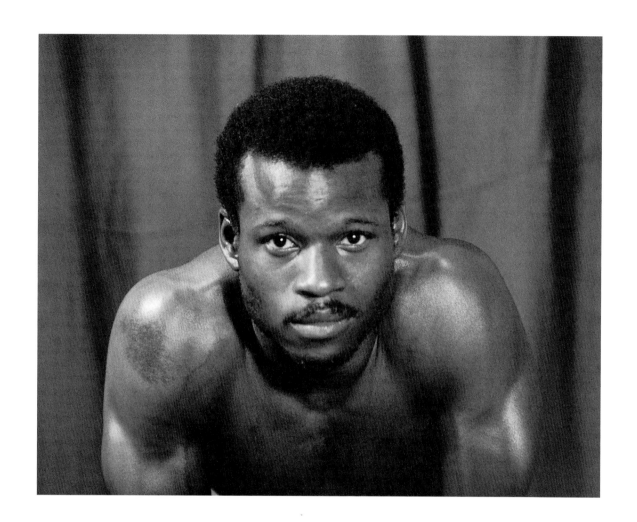

Kalle Pieper was born in 1959 in the small rural town of Ahaus on the border between Germany and Holland.

Kalle Pieper says of his childhood:

'There were many stories rich in mythological imagery, stories from the Old Testament with saints and miracles. There were colorful stained glass windows, clouds of incense and candles in old churches.

There was Carnival-time at the end of winter when every thing was permitted and there was the celebration of spring and its fertility with shrines to 'Mother Mary' in May. We had shrines in every bedroom with icons, candles and flowers picked in the fields.

Nature was all around and the seasons were powerful. Life around felt old and big. You could feel history. Every old tree and place had a story and of course there were plenty of old buildings, old churches and castles sourrounded by water.

You could still feel the mystery of the past that had happened all around you.

Life was measured in colorful rich pagan rituals that had put on a Christian coat as a very thin disguise.

Plenty of stimulation for a wild imagination. It was truly fantastic.'

Kalle Pieper studied Art Therapy at the 'Antroposophische Freie Kunststudienstätte' in Ottersberg near Bremen/Germany.

During his studies he was introduced to pre-Christian European mythology. Then, because of his interest in African music, he branched out into African mythology.

Soon it became apparent to him that the original mythologies before the advent of 'organized religion' were fundamentally the same.

After this discovery he hitch-hiked south from Germany, through the Sahara to West Africa, to experience people that practise these religions today. On his first trip, which took four month, he spent most of his time with his newly-found friend Mamadou and his family in Mopti/Mali.

After his return to Germany he finished his studies in Ottersberg with his thesis 'The Significance of Differences Between Body Languages of Different Cultures' and an art exhibit with paintings of African People in motion.

Right after this he went back to West Africa to spend another three months immersed in African Culture with his friend Mamadou.

Then, after working in Germany as an Art Therapist for a while, he followed his African-American boyfriend to the United States.

In 1987, San Francisco, he went from painting to fine art photography.

In San Francisco he discovered 'Santeria', the West African religion. It was called 'Ifa' in Africa and had been brought to the Caribbean and South America during the tragical slave trade, from there it had been brought by immigrants to the eastern U.S. and San Francisco.

Paolo Broggi, San Francisco 1998

Kalle Pieper wurde 1959 in der Kleinstadt Ahaus an der deutsch-holländischen Grenze geboren.
Kalle Pieper über seine Kindheit:

'Meine Kindheit war voller mystischer Bilder und Geschichten aus dem Alten Testament mit Heiligen und Wundern, Wolken von Weihrauch und Kerzen in alten Kirchen mit farbenprächtig bemalten bleiverglasten Fenstern.

Jedes Jahr zum Ende des Winters gab es Karneval, die Zeit wenn alles erlaubt ist. Im Frühjahr wurde die neue Fruchtbarkeit mit Maialtären der Muttergottes zu Ehren gefeiert. Wir hatten Maialtäre in allen Schlafzimmern der Kinder, bestückt mit Heiligenbildern, Kerzen und frischen Blumen, die wir auf den Feldern pflückten.
Die Natur und die Jahreszeiten waren allmächtig. Das Leben um uns herum fühlte sich groß und alt an. Man konnte die Geschichte spüren. Jeder alte Baum und jeder Ort hatte seine Geschichte. Natürlich gab es viele historische Gebäude, Wasserschlösser und Kirchen.
Man konnte die mysteriösen Dinge spüren, die um einen herum passiert waren.
Das Leben wurde in bunten heidnischen Ritualen gemessen, die einen dünnen christlichen Anstrich zur Tarnung hatten.
Eine Menge Anregungen für eine wilde Einbildungskraft. Es war phantastisch.'

Kalle Pieper studierte Kunsttherapie an der antroposophischen 'Freien Kunststudienstätte' in Ottersberg bei Bremen.
Während seines Studiums wurde er unter anderem auch in vorchristliche Mythologie eingeführt. Weil er sich sehr für afrikanische Musik interessierte, beschäftigte er sich auch mit afrikanischer Mythologie. Es wurde ihm sehr bald deutlich, daß die Mythologien sich vor der Zeit der organisierten Religionen im Grunde sehr ähnlich waren.
Mit dieser Erkenntnis reiste er dann per Anhalter durch die Sahara nach Westafrika um Menschen zu erleben, die diese Religionen heute noch praktizieren. Während seiner ersten viermonatigen Afrikareise verbrachte er die meiste Zeit mit seinem neuen Freund Mamadou und dessen Familie in Mopti in Mali.
Nach seiner Rückkehr nach Deutschland beendete er sein Studium mit der Examensarbeit 'Die Unterschiede zwischen den Körpersprachen verschiedener Kulturen' und einer Ausstellung seiner Gemälde von afrikanischen Menschen in Bewegung.
Danach ging er zurück nach Westafrika und verbrachte weitere drei Monate mit seinem Freund Mamadou, umgeben von afrikanischer Kultur.
Nachdem er ein Jahr in Deutschland als Kunsttherapeut gearbeitet hatte, folgte er seinem afroamerikanischen Freund in die Vereinigten Staaten.
In San Francisco kam er dann von der Malerei zur Fotografie.
Dort bekam er auch Kontakt mit 'Santeria', der westafrikanischen Religion 'Ifa', die während des tragischen Sklavenhandels von Afrika ihren Weg nach Südamerika und in die Karibik fand. Von dort gelangte sie dann mit Einwanderern in die Vereinigten Staaten und nach San Francisco.

Paolo Broggi, San Francisco 1998